Dolly Sen's Manual of Psychiatric Disorders

taking a subversive look
at psychiatry through art & mischief

The Diagnostic and Statistical Manual of Mental Disorders (DSM), published by the American Psychiatric Association, is supposed to be book on the classification of mental disorders, but reads more like an Argos catalogue, where you may or may not get what you ordered, handed to you in boxes by people who don't know you, and are just waiting for the next person in line to be a bastard to. The only difference is there is no warranty when they break your soul. I guess you can say I have no time for it. My own experience highlights the common experience that the DSM is at best a system of low scientific reliability and at worse a label-maker that promises you impersonal unbearable hell on top of very personal unbearable hell. The disorder is not within the person; it is psychiatry itself.

The DSM is a diagnostic tool that aims to pathologise all things human. For example, grief is part of being human; it is not a mental illness. The human condition is not a mental health condition.

I have been brutalised by psychiatry, and sadly I am not the only one. Those who have not gone through the mental health system have little idea of its abusive nature. The few decent people who work in the system sadly cannot subtract from the damage done

This book is a Dolly Sen Manual (DSM) of Psychiatric Disorder, to show by subverting or parodying the form you can the change the position of power to show how disturbing and fundamentally flawed psychiatric authority can be. And maybe that madness can make perfect sense.

Dolly Sen, 2016

MY MANIFESTO OF CREATIVITY & MENTAL LIBERATION

A manifesto declares to the world your beliefs, goals, and what needs to be made real.

I had my first psychosis at 14. I was lost in hell. Psychiatry didn't rescue me. I finally found my way into some kind of light in my 30s. If you, like me, have been residing in psychotic hinterlands for a good few decades, you realise when you re-join society, you are decades behind your peers. Your first love, job, career, home, relationships are new things in your 30s and 40s. People talk of lost youth like a misplaced item. Mine was never there in the first place.

When you stumble with the mistakes in middle age that most people dispensed with in their teens, it's humiliating and demeaning, it skins you alive when you have no skin to begin with. Your vulnerability feels like a coat of petrol in a world of fire. It adds shame to more shame.

Psychiatry & society say I should have shame for hurting because of trauma, shame that I am mad. I was told to

gain a thick skin in a world that gives me nothing to buy it with. I want a culture that doesn't produce a suicide every 40 minutes. I want a mind that doesn't produce a suicidal thought every 40 minutes. I had to stop hating myself.

So what do I do? My mind is too strange to pay the adequate amount of taxes. My soul is too hurt to accept any more bullshit. If I do not belong to this world, where is my map?

Luckily, I discovered creativity such as writing and art, which helped me express difficult feelings. I wrote poems about loneliness that made me feel less lonely. I realized I was drawing myself a map. If services and systems provide you with a map on how to be lost, and stay lost, you need to find the map elsewhere. Creativity has done that for me. I see arts as an opportunity to develop ways to reclaim identity from a mercenary, judgemental world that has abused it. The sanitised world insults my dreams and humiliates my soul. Asking me to be normal is asking too little of me, it asks too little of all of us.

The British artist Nigel Henderson said that art is the battleground for the human spirit. Madness might mean my mind is at war with itself but psychiatry has made me a refugee from my own soul. The guerrilla heart wants to

win. Most mental health difficulties are not about broken brains but broken hearts. And tablets do not mend a broken heart. Creativity knows the heart needs love, a new story, knows the heart should be respected and be exceptional.

You need to free your mind twice, before you tackle mental pain, you have to free yourself from psychiatry. Label yourself creative thinker rather than broken mind. Too many of us are given the message that our inner realities, our very selves are pathological and must be hidden. Too many of us feel like lesser beings. How can it be lesser if we can, through creativity, make it is bold and colourful and beautiful as we like. That is what creativity is: the power to change.

Robert Motherwell, the artist, said he felt 'unwedded to the universe'. I feel unwedded to the universe, adulterous to the breath. How can I love the bruised whore of my being, when I want to be with faithful death. But art weds me to the world by changing the way I look at it, and changing the world itself.

Let's not beat around the bush, psychiatry has defined your mind as ugly, but why do you see your mind as ugly when I see the beauty of it? Why are other people owning your definition? Who says you are you? Who has written

your script? If you don't like your script you are living, write a new one. If you don't like the people around you, recast the characters. I realised this for myself. I realised I was giving my narrative on a plate to those who couldn't even write a Pot Noodle ad. Also, I think psychosis is a story/experience that can't be faced in its purest form. Creativity can help that with its gentle re-writing.

Someone in a film I did called 'Greenhouse of Hearts' talked about madness and art. And he said something along the lines of "art bridges madness to the rest of the world, and it gives it a language that is better suited to the experience." And it's true. Words like disorder, pathology, false beliefs don't explain my experience or help me make sense of them; creativity does.

Creativity is a voice that compels you to create with as much rigour as psychotic voices. To me the difference is whether the voice in internal, dancing on your skin or far away because it is too painful to be inside. What is the creative process but a voice, and what is art but a ghost that forces itself to be real?

Psychiatry or normality does not tell truth of me. My art show the truth of me: broken child, but Sellotaped with glitter and stars.

When you look upon your mind with the eye of a painter, you can look upon it with curiosity and wonder. You can ask yourself why this crease is there, why the light is stronger here. And why does the shadow always falls on that thought or dream. Can you make your world beautiful enough to save your soul?

But it goes beyond art as therapy. I think reality is a cheeky bastard, and I am putting him over my lap and slapping his naughty arse through my art. I have done it with things like 'I helped a normal' sticker or writing the Mad 10 Commandments, which are:

1. Thou shalt not kill free thought.
2. Do not worship the rat race, get off the rat and ride the unicorn.
3. Your story must be written by you.
4. Do not make pathology or normality your idol.
5. Do not hurt anyone, including yourself.
6. Honour your soul and the souls of others.
7. Do not let people steal you from yourselves.
8. Do not lose your sense of humour.
9. Do not covet normality.
10. Do not follow commandments.

If I could sum up my manifesto in a few lines: Don't be a little flame ashamed of the light you shed. Time to shine and embarrass the sun, the stars. Subvert the world and insist it be beautiful.

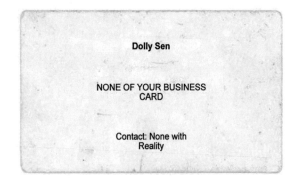

Dolly Sen

NONE OF YOUR BUSINESS
CARD

Contact: None with
Reality

HOW TO BE MAD

So, how to be mad? Being human helps. Being a human in an inhumane world and you are halfway there. Some people go mad reacting to the 'soul death while you wait' capitalistic culture. For some, madness is a family affair passed down the generations, and some react to abuse and trauma, where serotonin dances badly in a violated head. When people ask me why I am mad, I say in response 'Why aren't you?'

I do consider these a strange breed – those who never go mad, not even for five minutes. In this fucked up world, those who have no mental pain are scary bastards. I am sorry; I would not like to be stuck in a lift with them. They'd probably start singing 'Kum by yah' or something.

If you want a short cut to the road to madness, then become involved with the mental health system. They will find something wrong with you – that is what they are paid to do, and they will do it with such bureaucratic passion, your sensitivity will disgust itself.

A LIST OF WAYS TO GUARANTEE MADNESS (OR HOW PSYCHIATRY SIGNPOSTS)

Go to page 102 for answers

THE FUNDAMENTAL GOOD OF HUMANITY

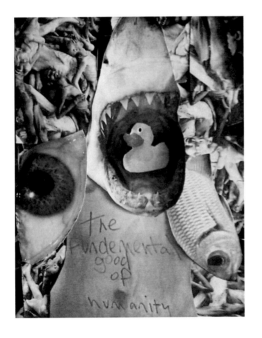

Maybe I was just feeling all that was wrong with the world, but in my psychosis, human beings were growing shark heads.

Is psychosis a collage of the cutting outs of reality? Dunno. But my source material isn't Women's Weekly, it is the complex human being.

I get frustrated with people who say humans have fundamental goodness. Tell that to any human being who has died at the hands of someone of his or her own species. It's an insult to them.

No genocide victim will wear that t-shirt, I am afraid. There are both sides to the human. The only thing axiomatic about it is the choice between the two.

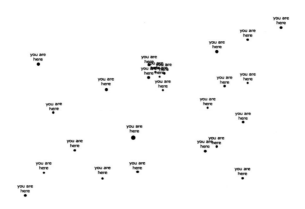

'You are Here' relates to the theme of Invisibility in a number of ways. On a personal level, it is what psychosis feels like, the mind all over the place, lost and invisible to the self. As a 'mad' person I feel there is no place for me in society – being told where I am but having no place to call my own. Told what I am and where to be, but I am nowhere to be found.

JESUS HAS AN EBAY ACCOUNT

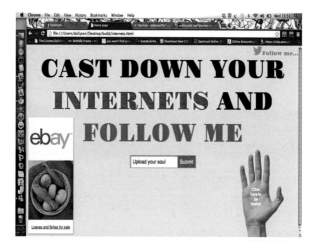

I did have a failed career as Jesus in the early noughties. Should have had better social media presence. In 2014 I created a website that went through a psychotic episode, including a page that thought it was Jesus. Somewhere you could be healed, buy fish & loaves starter kit and upload your soul. http://www.internetbreakdown.com

APOCALYPSE LOYALTY CARD

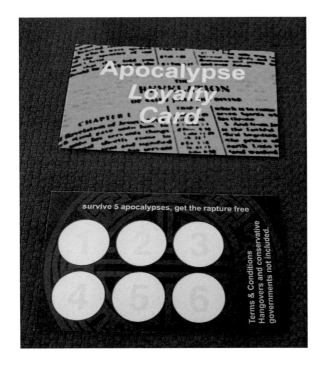

I didn't have much faith in myself as Jesus so created these
Apocalypse Loyalty Cards, just in case.

MACARONI CHEESE
FOR THE 5000

Ingredients

Serves: 5000

- 312.5kg macaroni pasta
- 50 kg butter
- 50kg plain flour
- 1320 pints of milk
- 375 kg grated do you believe in cheeses

Method

No cooking required, I'm Jesus innit.

PSYCHIATRY - ASSESSMENT & TREATMENT OF YOUR UNBEAUTIFUL SOUL

How can anything beautiful come out of a profession that sees your mind as ugly?

PSYCHIATRY'S DISCLAIMER

You do not have the right to say anything without it being used against you. Anything you say can and will be used against you. You have the right to legal assistance. If you cannot afford legal assistance, you are buggered. Do you understand the rights I have just read to you? With these rights in mind, do you wish to engage in our therapeutic relationship?

THE INSTITUTION ATTENDANCE RISK ASSESSMENT FORM (T.I.A.R.A)

NEGLECT

Are you at risk from neglect from services?

Is there a previous history of neglect or inadequate care from services?

EXPLOITATION

Is there a risk of exploitation?

Are they going to gain financially from your vulnerability?

VIOLENCE & AGGRESSION

Is there a history of violence and aggression from staff/system?

Have you been physically restrained? Forcibly medicated? Forcibly ECTed?

Has it caused you physical pain?

Has it caused you trauma?

SEXUAL ABUSE

Have you previously been sexually assaulted in a psychiatric unit, by either other patients or staff?

Did you report it and no action taken?

SUBSTANCE MISUSE

Have you been forced to take drugs that have known negative health implications, including death?

INSIGHT

Does the mental health system have insight into its abusive nature?

DIGNITY CANNOT BE TAKEN
FOUR TIMES A DAY

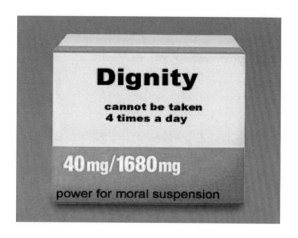

Being labelled, pathologised and medicated,
I cannot claim my mind for myself
I cannot claim my life for myself
So how can I even have dignity?

Medicine does not heal
But seals the scream
Is that dignity?

Dignity is never in the side effects.
Weight gain – my arse is getting bigger than my dreams.
Too tired to reach for the day, let alone the sun.
Try having sex without coming – dignity?

Love with a lot of going – dignity?
A journey of a thousand miles starts with a single step, but
try it with a Largactil shuffle.
Constipation does not feel like dignity
How can I sing the song of dignity, drooling?

I would walk away with my head held high, but am too
tired, too alone, too despised.
But let's put aside the pills for a moment.
Is dignity in the waiting room?
Is it in the set of eyes that sees you as a sickness?
How much does dignity cost exactly? It's not in our budget
this year. It's not in the economic case.

Dignity is not in the control and restraint; face down,
begging to breathe.
It was not in the staggered silence of my 'community care'.
It is not in the 'burden of care' phrase.
I am still waiting for my appointment with dignity.

Dignity means not begging for my identity, my dreams, it means not begging to be heard, to be cared for.

Dignity means honouring the person, but not being hated will do.

Dignity cannot be taken 4 times a day.

And shouldn't be bitter pills to swallow...

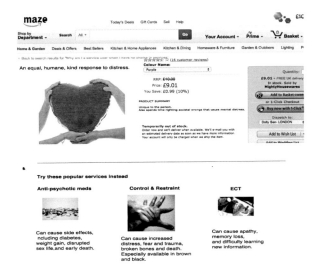

Why am I called a 'service user' when I have no choice in services? If I went to Argos for a kettle and somebody pumped me full of drugs I didn't want, pushed me on the floor because I complained my kettle was faulty, or electrocuted by said kettle, you know, I wouldn't go want to go back. This 'service' affects more than your statutory rights. No refunds or exchanges for missed life.

THE B0RED'S PRAYER

Our psychiatry
Who would section heaven
Hallowed be thy name
My freedom gone
Thy will be done
Force and restraint, let's forget compassion
Give us this day our daily meds
And forgive not our differences
As we submit to those who trespass against us
Lead us into painful sensation and mental
Castration
Forever and ever
Again.

ONE STEP SANITY MAINSTREAM TEST

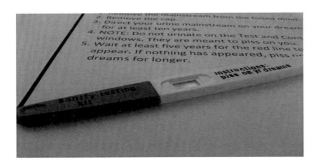

Please read all instructions. They will tell you what to think, do and feel. Failure to follow instructions may impair your ability to be part of the machinery.

How to use test:

- Remove the mainstream from the foiled mind.
- Remove the cap & direct your urine mainstream on your dreams for at least ten years.
- NOTE: Do not urinate on the Test and Control windows. They are meant to piss on you. Wait at least

five years for the red line to appear. If nothing has appeared, piss on your dreams for longer.

SHAME ON THE NHS

Karmacy Stamp			Name
			Dolly Sen

Endorsements

Shame Shame Shame shame shame

Shame Shame Shame Shame Shame

Shame Shame Shame shame shame

Shame Shame Shame Shame Shame

Shame Shame Shame shame shame

Shame Shame Shame Shame Shame

Shame Shame Shame shame shame

Shame Shame Shame Shame Shame

Shame Shame Shame shame shame

Shame Shame Shame Shame Shame

Shame Shame Shame shame shame

Shame Shame Shame Shame Shame

signature of prescriber date

for dispenser,
how many
dreams on form

SHAME ON THE MENTAL HEALTH SYSTEM

Tell me your shame.

What are your most shameful secrets?

You are not going to tell me? Then you must be sick?

You need treatment. You need my expertise.

My expertise means I can have no shame

I can hide it

But you must always tell me yours when you see me.

Must I restrain you to protect me from myself?

Have more shame to drown you.

You must engage.

You must engage in your shaming.

I don't know why you are not getting better.

The professionals who do not inflict shame are few and far between, but there are a few.

PRESCRIPTION OF STARS

Finally, you prescribe me stars
Not shame, nor loss of soul as side effect
You prescribe me holding my head up high
To find my soul again.
It is easier to see under a light.
Finally the universe is open to me
Where I can fly, standing still.
Because I have my stars

Pharmacy Stamp	Age	Title, Forename, Surname & Address
	41	Dolly Sen
	D.o.B	

Please don't stamp over age box

Number of days' treatment
N.B. Ensure dose is stated

NHS Number:

Endorsements

Signature of Prescriber

Date 17/7/2022

For dispenser
No. of
Prescns.
on form

NHS 52520352922

FP10SS0608

I. O. U. A LIFE

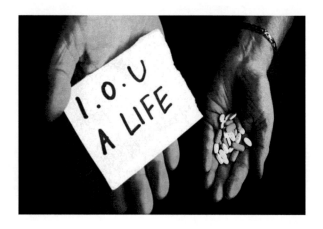

I have been labelled 'mad' by society, so therefore seen as unbalanced. Society's way of redressing that is not to help me make sense of the childhood trauma that triggered my psychosis, nor to tackle inequality and discrimination in society because of that label. Its way was to medicate me into submission. For decades I was on antipsychotic medication. I did not laugh or cry on these meds. Is this well balanced? It took away my symptoms but my life too. Is that a fair payoff, a balanced payoff?

A tablet does not cure abuse, isolation, or stigma. But I was sedated, out of society's hair. They said the tablets would make me feel better. Please define better when I have lost my soul. Maybe you don't need a soul nowadays.

The message: don't speak your mind. Your silence and submission are signs of being well balanced.

So my art shows that the medication weighs heavier, and the promise of peace of mind, of having my life back is an empty promise, not worth the prescription pad it is written on.

I have given up the meds and regained my life. Some may say that shows I am unbalanced. I say it makes perfect sense.

HOW TO MAKE A MENTAL HEALTH PROFESSIONAL FEEL AWKWARD WITH TWO SIMPLE WORDS

HUG ME

STIGMA & DISCRIMINATION

Worldwide, there are many government-funded initiatives organising anti-stigma campaigns around mental health. Their use of the word 'stigma' is deliberate, because if they used the word 'discrimination' instead, it would be a whole different ballgame. It would mean the focus would have to go beyond the individual, and systemic changes would have to be enforced, but no government is going to champion or fund a campaign which highlights the damage and discrimination they knowingly inflict upon countless mad people. Instead, they sponsor campaigns fronted by millionaire celebrities to be the spokespeople for lives of demonised and lonely poverty. Or ask you to have a cup of tea and discuss mental health with a workmate. All very dandy for the worried well, but I find if you talk about being Jesus, people don't finish their cup of tea.

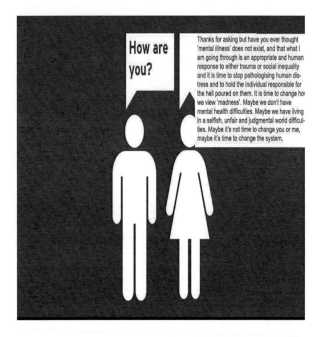

This is a send up of the UK's Time to Change stigma campaign, where the two figures make polite small talk about mental health. I think the discussion needs to be more like this.

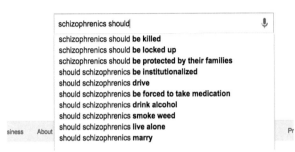

This is what happens when you Google 'Schizophrenics should'. This is a truer public perception of schizophrenia. The anti-stigma campaign still alienates and makes us different creatures to everyone else.

I am waiting for it to say 'Schizophrenics should not be so bloody sexy'.

ADOPT-A-NUTTER

Being mad means being poor. Being mad means being rejected by society and sometimes your family. It can be lonely. So why not adopt a nutter? The benefits are many: whenever you have company you want to get rid off, introduce them to the nutter in your family. They will magically disappear. Maybe you have a business rival...just introduce a nutter as your rival's relative... they will all come running to you for your products...

£1.50 will buy a coffee to counteract the sedating medication will buy cleaning fluids so the nutter can clean the eggs thrown on their front doors by normals

£5 will pay for telephone bill costs of the nutter trying to contact a professional to help them when they need support but find themselves having their phone calls not returned.

£10 will pay for the junk food that nutters eat because the medication makes them crave sugars and fat

£15 will pay for a nutter walker - they will take your nutter out for a run, so they don't lie in bed all day and they can scare off your neighbours ...

£17 will buy new shoes. The old shoes being worn thin from the largactyl shuffle

£20 will pay for sex toys. Nobody wants to go out with a nutter, bless them and anyway the medication makes the poor dears impotent (it's a blessing really)

£50 will pay for Eurostar ticket out of UK after hospital escape.

£1000 will pay for the nutter to stay out of the UK so they can't scrounge off the benefits.

MAD GENIUS?

I was asked to be part of a panel discussion on the concept of the Mad Genius at the Basement in Brighton on October 8ᵗʰ 2014.

It was unanimously agreed that the 'mad genius' label is dangerous, and the three reasons that kept coming up was the fetishisation of the mad, the pedestal the person will be put on, and how it still makes the person 'the other'.

I agree with all that but my position remains ambivalent. To me, it is a seductive label and all the arguments against it just pushed me on the swing but not off it. The fetishisation of the mad goes beyond the geniuses.

The 'mad' apparently don't own their minds or their identities. It is an alienating label but maybe some of us want to be alienated, and not assimilated, and we can customise our pedestals with stair lifts and glitter. If I were accepted by society, I would look to see what part of my soul was lacking.

My psychosis can go but the world will still make me mad. Mad genius is a seductive label because what do you put in the gaps on your CV? Being mad means your

identity is dragged backward through shit and sunshine. Adding on genius elevates that humiliated identity.

It was interesting the debate centred around that it wasn't a good label or identity, but I did pose a question no one seemed to answer: what's the alternative, if you dropped 'mad' and didn't fit into 'sane', what the fuck do you do with your mind, life, identity and work pension?

I am no genius, but I am definitely mad. I pose a question to my readers: what do you call a person who wants to put reality over her knees and smack his naughty arse?

Until I get an answer, I will continue to screw light bulbs into the sky.

WHAT IS MAD CULTURE?

It is a celebration of the creativity of mad people, and pride in our unique way of looking at life, our internal world externalised and shared with others without shame, as a valid way of life.

It is an acknowledgement that we are reacting to a society that is scared of us and will hijack our art and literature once our artists and writers are dead and therefore deemed safe and easy to control, corrupt and capitalise.

Our culture is that we have control of our lives without being brutalised by a psychiatric system that wants us to conform to an ideal of normality that doesn't exist anyway. It is challenging the idea that madness is something to be hidden; it realises that visibility counts in order to break the stigma that has a stranglehold over every single mad person alive today. Mad Culture is saying, 'Yes, yes!" to life even if embarrasses the 'normals'.

Mad Culture is saying: I won't hold your sanity against you. My reality is good enough. Is yours? Not all mad people are artistic, some are quite happy to be

accountants, and I don't think mad accountants should be discriminated against.

We are already an alienated sector of society, in fact the most alienated sector of society. We are not full members of this society or culture and that is not going to change without us changing it. Because why is it in their interest to change what makes them feel comfortable and superior. So in that sense we need to create our own culture in which we feel comfortable. Some would argue that leads to separation, but we are separate. Where does madness fit in 'normal culture'?

We are the untouchables. Only fit enough to work in sheltered workshops, to be cleaners, media scapegoats and to paint multi-million pound masterpieces. Put simply, in this present culture we have victim status; in our culture, we are just ourselves. WE want a culture that doesn't produce a suicide every 40 seconds.

Why have pride about suffering distress, some may say? It's not about that. It is pride in our strength to survive that distress and what it teaches us, and not to feel like lesser beings because of it, and to question why we feel lesser beings because of it, to question that madness is an illness and not a human response to a sick society, a sick upbringing.

Can you imagine a world without music, art, dance and drama? It would be an empty, bland place. So why is the world without your music, art, dance and drama? If life is a stage, is yours worth watching? What would make the show better? Can we change the ending? Or make it a better story? Culture is letting us tell the story not them – it is as simple as that.

POOR BASTARD NORMALS

Some people tell me that there is no such thing as normal and jokingly say that they are not, but they haven't stepped outside being normal for long enough to know. If you are not normal, you get to know about it quickly and heartbreakingly. You wouldn't be incautious enough to say that the tyranny of normality doesn't exist.

Those who say 'there is no such thing as normal' don't bring down psychiatric institutions (why do we need them if no-one is normal), they still laugh and avoid those dragged into them.

Time to laugh at you, normal.

You know you're normal when...

You know you are normal,

> *when you get compassion fatigue but you are never tired of being judgemental and selfish.*

> *When you say to a person who gives up the ratrace to follow their dreams: are you mad?*

> *When you never complain to people who are in a superior social position to you but go straight for the easy targets.*

> *When despite being more at risk from a 9 to 5er coming out of a pub or a family member, you think mad people are dangerous.*

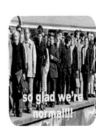

> *When you think a taxpayer has more worth than those who don't pay taxes.*

> *When you say asylum seekers have come to this country to steal your job even though you are not a toilet cleaner or janitor, or say they are here for the cushy life, yes, you usually do want that after you've been tortured or have lost a family member to violent regime.*

> *When you don't worry about a Third World that is manmade, because the running shoes it cheaply produces look good on you.*

> *When you don't worry about pollution or the wars that come out of oil, because cars represent freedom.*

Some of us who have been labeled with disabled minds find normality tedious and desperate and our own experiences belittled and devalued. To use a technological analogy, madness is seen as malfunctioning in the programming and not an appropriate reaction to the system that it finds itself in? The divergent mind is not a spam folder. But fundamentally it asks: What if the screen of your being says: 'No life to be found. The life you are looking for might have been removed, had its name changed, or is temporarily unavailable. Maybe psychosis is the programme that wants you to find your soul. Normality or sanity is the Microsoft of reality, it has the monopoly, but it's not the only programme there is. Society disables me by putting viruses of self-hate and discrimination into that programming, and then tries to sell me sanity at inflated prices, only to make my system crash again and again.

To that end, I want to disrupt systems that produce 'copy and paste' identities/thoughts/perceptions/life/death, as a Trojan horse dressed as a My Little Pony on acid with a little sadness in their hearts. My anti-virus programme is my art and creativity; it is putting sanity over my lap and smacking its naughty bum bum.

Some normal people lack insight and need rehabilitation. It is my duty to help them out by pointing out that sanity is full of ridiculous acceptable behaviour and strange double standards, such as seeing street art as vandalism but the proliferation of demeaning ads selling pointless things as acceptable. That being loud, aggressive whilst drunk is someone being one of the boys. But if someone is shouting due to being troubled by voices, it is reason to be more scared, even though you are more likely to be injured or killed by the former. The world is sanitised not sane. Why is acceptance and celebration of the mad self seen a lack of insight, when it has been forged by thought, pain and lots of questioning. There is a side to madness that doesn't get shown, that is intelligent, funny, and pointing of the emperor's new clothes. A lot of that has been done through my art.

Previously, I created a part of the website experiencing psychosis, which hears voices, thinks it is being spied upon,

and that it is Jesus. It asks: what if the internet experienced madness, what would it look like, would you ever return to it, would you bookmark it, would you share it, report it, what does it feel to vicariously experience psychosis? Virtual reality may not exist, but what if it didn't exist twice removed.

I hope my art infects normal systems with subversion and cheekiness. Reality may never be an inclusive design, but virtual reality can be. In fact, artificial intelligence can never be sentient, if it cannot go mad.

So how to subvert technology that wants to fix the mad mind, or show that interventions for mental health conditions do more harm than good? Maybe medicate and forcibly restrain a robot? Develop a depressed search engine who tells the person there isn't any point in looking for what they want? Give YouTube hallucinations? A dating website for people's voices? Make a Twitter account paranoid that people are following it?

One of the other technologies on offer around mental health is a proliferation of apps, measuring mood, anxiety, negative thoughts, and aspiring to teach people how to calm themselves, breathe, and how to get a better night's sleep. All well and good, but the problem is making it

the individual's problem or responsibility. No matter if your distress is caused by social factors, such as poverty, oppression, racism, welfare cuts, or disability as burden rhetoric. It is not life-improvement, it is subservience-improvement. Maybe it is time to develop and app to measure the unreasonableness of society's expectation of you. Or a motivating app, which flashes messages like 'You don't have to fit into their bullshit.'

Or maybe it's time to show how differences in mind give you much more to think about.

HELP THE NORMALS

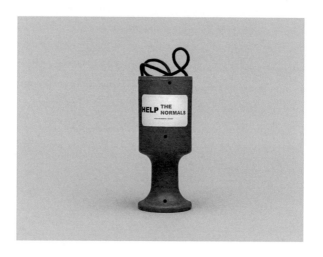

£3 a month will help pay for parking fines for bastardly parking in a disabled parking bay.

£3 a month will pay for coffee from bastard multinational companies who don't pay their taxes.

£3 a month will pay toward a Daily Mail subscription to feed bastard prejudices.

£3 a month will go towards paying bastard bankers to give you the bastard privilege to blame it all on immigrants.

My 'Help the Normals' art piece makes a mockery of the charity model of disability, by switching the position object of pity and giver of pity.

Think about it this way: If you take a normal person, and use purposefully degrading and humiliating language to turn them into something to pity. For example, changing the word 'normality' into 'mediocrity' and 'typical' to 'boring and average'. Then throw money at them and expect them to know their place as a poor, pathetic thing, I think they will then 'get' why charity is not the way forward for disabled people. It is better to have rights, equality, and the withdrawal of oppressive practices, than someone's commiseration and spare change.

NOW FOR A
COMMERCIAL BREAK

THIS AD HAS BEEN
DETAINED UNDER SECTION
136 OF THE MENTAL HEALTH
ACT FOR BEING A DANGER
TO ITSELF AND OTHERS.

RECOVERY'S CHOCOLATE STARFISH

A chocolate starfish is slang for arsehole. The recovery star is a tool to measure change with goals orientated to work, responsibilities, and other personal routes to lives of quiet desperation. The connection between the two is easy to make. External factors like poverty, discrimination, and trauma cannot be part of the equation. Those stars would crash into psychiatry and shatter it into a thousand pieces.

The recovery movement started out with good intentions in the late 1980s, steered by survivors themselves, a grassroots initiative to change the system to provide hope and opportunity as a rejoinder to the belief that mad people could never get better or aspire to do anything meaningful.

I was lost in the burning forests of psychosis for at least two decades. Medication did not put the fire out, it just made me not care about it. On my 30th birthday I gave myself a choice: to live or die. I chose to live and give life everything I had, and because of that decision, I have had over 10 books published, exhibited art internationally,

performed widely, had prestigious film commissions, and spoken influentially at such places as the World Health Organisation. To use mental health jargon, I have 'recovered', even though I still can get very distressed to the point of suicide. I have become functional, yet I am still too strange to pay a tolerable amount of taxes. I wrote & taught around Recovery, working for the UK's first Recovery College, I was the recovery model's poster child. I believed the rhetoric. But working within the recovery model, I noticed how bit-by-bit the recovery ideal became colonised by services to serve their own insidious purposes. For example, discharging people from Community Mental Health Teams if they attended the Recovery College in a cynical attempt to fob off a 2-hour education session as a viable alternative to having personal, on-going intervention and support. What I found out was Recovery isn't about people living their dreams or having less distressed; it's about reducing us as an economic burden. We believed the spin and our position of alienated humanity and quieter distress doesn't make us jump for joy, funnily enough.

Just because you become less mad, it doesn't mean you lose the distress, or lose your estranged position in society. We've learned coping skills to help other people cope with

our distress. We have learned not to make a fuss of hurting so deeply. The recovery model is a sick pied piper leading the hurt into disquieting but silenced shame. It is also eating shit and pretending to benefit from the meal. Please try to look like you are enjoying it.

RECOVERY'S NO MAN'S LAND

The problem with the recovery model is that it is a medical term, and is expected to sit safely and warmly in the medical world. The recovery model says you need to look beyond the symptoms and see the person. But the whole relationship between service user and professional is regulated by the symptoms, depending if your symptoms go up or down, decides what treatment you get, if any at all.

It also assumes that there is an illness to recover from. It minimises the fact that mental and emotional pain can sometimes be a very human and very appropriate response to trauma, poverty or oppression, and for it to be pathologised and turned into a sickness insults and negates the person's story. It also begs the question, who decides who is recovered? At what point is someone recovered? Is it when they don't fit the mental health system's criteria of what mental distress is? When they are taxpayers? When their appropriate response to distressing trauma becomes suppressed distress? When they shut the hell up?

I came across the idea of recovery before I came across the model, and it didn't need to fit the model because it

was truly personal, it was deep, meaningful understanding that I had the power to change things for the better. I had hope before the recovery model, it can't claim it as its own, it shouldn't steal my thunder or my accomplishment; the system had nothing to do with it, and in fact has made my journey harder not easier.

There are lots to say about the recovery model, but it gets it misses the point in so many places. For example, work is seen as a goal in recovery, but the model does nothing to look at stigma and discrimination in the workplace, or trying to change that. Is the world or workplace going to welcome with open arms someone who says hello, my name is Dolly and I hear voices? The fear around mental health is still there, and the recovery model has done near to nothing to tackle that. The problem with the recovery model is that it puts all the responsibility on the service user and none onto society. YOU can change your life, but can you change how people respond to you?

Is recovery about being well enough to be thrown into the world of sharks? I can see how some people don't want to 'recover' because they are suspicious of rejoining the world that hurt them or made them have a breakdown in the first place. Where is the recovery model for the society

of sharks? Or is the aim of recovery to turn you into a part of a judgemental, vernal cruel society that probably drove you mad in the first place?

So is recovery the right word? Depends if it has power and meaning for you. It doesn't for me, finding the dollyness of dolly is not a medical phenomenon, it is an emotional and spiritual one, it is a human one, and humans were discovering and healing themselves long before psychiatry came along.

The other thing they don't tell you about the recovery model is that it will lead some people into no man's land.

If you, like me, have been residing in psychotic hinterlands for a good few decades, you realise when you rejoin society, that you are decades behind your peers. You are in a continual state of catch up, and when people ask where you've been you show a passport stamped with lands no one has visited. I cannot return to the familiar tyranny of psychosis, even though I still think in that language. I have become a stateless person, not accepted in my new land, normality's refugee. Too many people do not want me to be part of their home, their culture. I can't give them what they want. My dreams do not belong in this world. I can't say society is meaningful and that I am

happy to be part of it. It is very ugly in places, and I am not supposed to get upset by that. That's life, I am told, and life's not fair. I know that, but why does that mean human beings should forget to try to be fair?

I can't return to where I came, and I don't like where I am going. No man's land is land that is unoccupied or is under dispute between parties that leave it unoccupied due to fear or uncertainty. Historically, no man's land is a dangerous strip of land, or a place of execution. Where can I go to explore a place that is mine? Will I bump into others straying into this lost part of the land?

Art provides the cartography of this land, and that is what follows these pages.

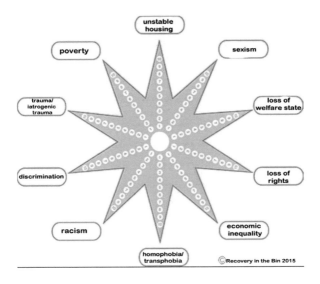

The Recovery Star is a tool used in mental health services to encourage and measure 'recovery' using destinations such as work, responsibilities, and living skills as proof that your recovery journey is well on its way. The Recovery Star is supposed to shine on this personal endeavour to lead the way. It conveniently forgets all the external factors that can cause distress, such as poverty and discrimination. The Recovery Star then becomes a tiny dot in the dark and painful night mad people walk under. I am part of

a group called 'Recovery in the Bin' and some members were batting around ideas how to offer an alternative unheavenly body. I took on the ideas and knocked up the 'Unrecovery Star' in its first draft. Then all of us in the group collaborated to produce what is on the previous page to show what makes us go mad. This is what stops us living our lives without pain, this is why we can't move on to health and meaningful life.

For more info on Recovery in the Bin, go to: https://recoveryinthebin.org/

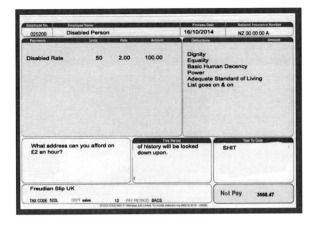

This artwork was done in response to a Lord Freud suggesting in Oct 2014 that disabled people are 'not worth full wage'.

Sanity Feedback Form

1. The instructions to sanity are clear and accurate.

○ Yes

○ No

○ Nipple tassles

2. Sanity is comfortable and well-equipped.

○ Yes

○ No

○ N/A

3. How do you rate the quality of sanity?

○ dissatisfied

○ Satisfied

○ Neither dissatisfied or satisfied.

○ Other (please specify)

[]

4. Would you recommend sanity to others?

○ Yes

THE REVOLUTION WILL NOT BE MEDICATED

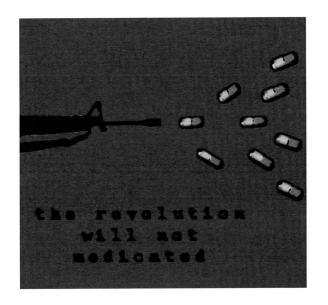

The Revolution will not be medicated
No forced stillness and wiped dreams
No being held down
For being different

No sedation for the screams
We are screaming for a reason
Our hurt will change the world
Because the world won't change our hurt

The side effect of life
Is the need for it to be ours
The revolution will not be medicated
You cannot anaesthetise hell
You cannot desensitise the broken heart

Madness is seen as revolting
Thank fuck

MADNESS IS FOR LIFE NOT JUST FOR CHRISTMAS

INTRODUCTION

I hate Christmas. I don't want to celebrate it as a religious festival or a consumerist tryst. But I do because the people I love do enjoy it. I find it stressful, it brings back traumatic memories, and I am in a dissociative fugue for most of it. Madness is wrapped with razor tinsel and clothed with many extra layers of pain at Christmas. I needed to find a way to survive it, and so created a Madvent, my take on the traditional advent calendar as a mad person making fun of the system.

DAY 1

DAY 2

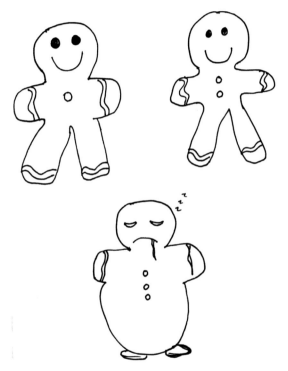

JEFF THE GINGERBREAD MAN HATED
BEING ON ANTI-PSYCHOTIC MEDICATION

DAY 3
Lidl donkey, Lidl donkey

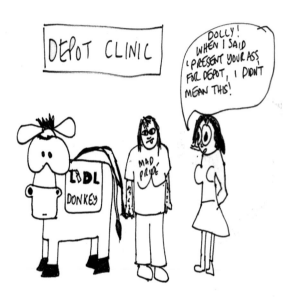

DAY 4

Jingle pills, jingle pills

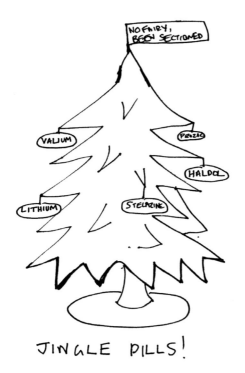

JINGLE PILLS!

DAY 5

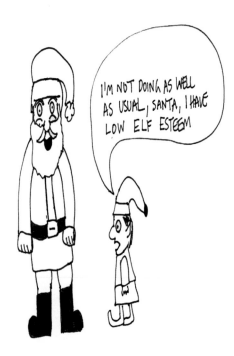

DAY 6

They don't play reindeer games in rehab

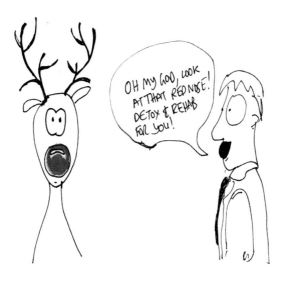

DAY 7

DAY 8

'Beware of false knowledge, it is more dangerous than ignorance.'
George Bernard Shaw

THE 3 WISE MEN

DAY 9

Equal opportunity coercion for Xmas

DAY 10

It's a cold, cold world.

DAY 11

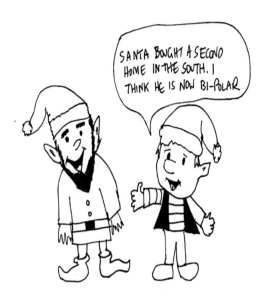

DAY 12

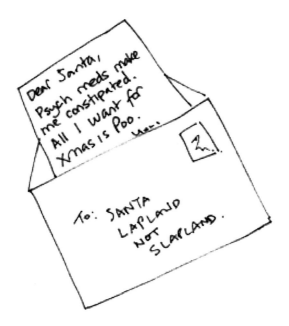

DAY 13

It's not the thought that counts.

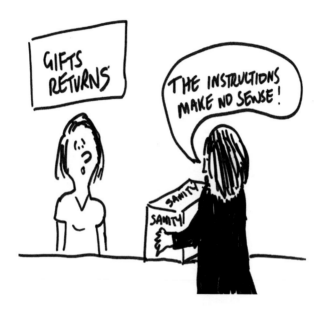

DAY 14

The secret ingredient to life

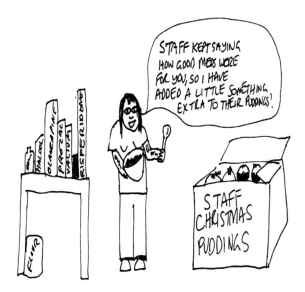

DAY 15

DAY 16

DAY 17

No room at the bin

DAY 18

Decades of psychiatric meds can affect your body in all sorts of ways.

DAY 19

Sharing the love

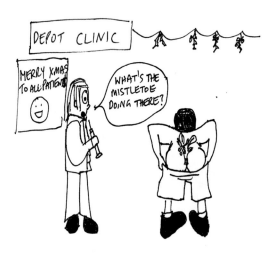

DAY 20

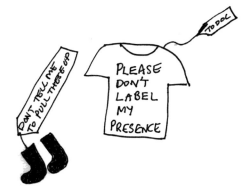

DAY 21

THIS MADVENT HAS BEEN
SECTIONED UNDER THE
SECTION 136 OF THE MENTAL
HEALTH ACT. IT HAS BEEN
TAKEN TO THE RECYCLE
BIN, THE MOST LOCAL PLACE
OF SAFETY!

DAY 22

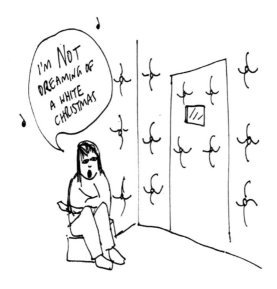

DAY 23

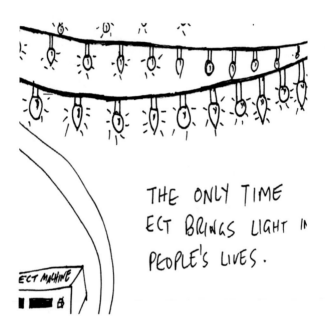

THE ONLY TIME
ECT BRINGS LIGHT IN
PEOPLE'S LIVES.

DAY 24

The gift of medication…

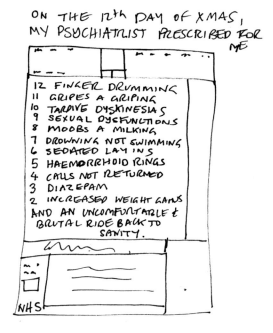

ON THE 12th DAY OF XMAS,
MY PSYCHIATRIST PRESCRIBED FOR ME

12 FINGER DRUMMING
11 GRIPES A GRIPING
10 TARDIVE DYSKINESIAS
9 SEXUAL DYSFUNCTIONS
8 MOOBS A MILKING
7 DROWNING NOT SWIMMING
6 SEDATED LAY INS
5 HAEMORRHOID RINGS
4 CALLS NOT RETURNED
3 DIAZEPAM
2 INCREASED WEIGHT GAINS
AND AN UNCOMFORTABLE &
BRUTAL RIDE BACK TO
SANITY.

NHS

DAY 25

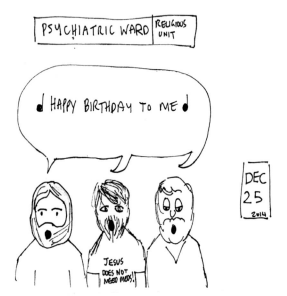

SOME USEFUL MENTAL HEALTH GUIDES

see more of our how to guides

How to:

- Avoid receiving a diagnosis of personality disorder

- How to put your brain damage to good use after ECT

- How to breathe under control and restraint

- Make tasty milkshakes from medication lactation

- How to have a nice bum for your depot

© Dolly Sen 2015

Mindless How to Guides

How to avoid

receiving a diagnosis of schizophrenia or psychosis

Mindless Guides

Some Don'ts

Do maintain a positive thumbs up attitude to your brutalisation from the mental health system

1) Do not insist your voices are minuted in meetings.
2) Do not offer to turn hospital macaroni cheese into enough for the 5000.
3) Do not offer discount healing to professionals.
4) Do not say 'you can't section me, I can walk through walls!' and then proceed to demonstrate it.

5) Do not say 'Of course I don't mind meds causing lactation' and then offer them a glass.
6) Do not turn the Largactil shuffle into a moonwalk.
7) Do not say 'Of course, I will be compliant, mein fuhrer.'
8) Do not demand equality and respect, this is a symptom of your illness.
8) Do not forget to say thank you to staff whilst under control & restraint for their care and compassion.

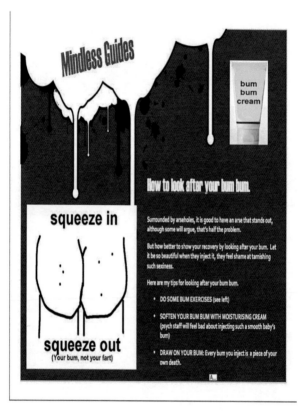

Mindless Guides

bum bum cream

How to look after your bum bum.

Surrounded by arseholes, it is good to have an arse that stands out, although some will argue, that's half the problem.

But how better to show your recovery by looking after your bum. Let it be so beautiful when they inject it, they feel shame at tarnishing such sexiness.

Here are my tips for looking after your bum bum.

- DO SOME BUM EXERCISES (see left)

- SOFTEN YOUR BUM BUM WITH MOISTURISING CREAM (psych staff will feel bad about injecting such a smooth baby's bum)

- DRAW ON YOUR BUM: Every bum you inject is a piece of your own death.

squeeze in

squeeze out
(Your bum, not your fart)

HOW TO MAKE A MILKSHAKE FROM MEDICATION LACTATION

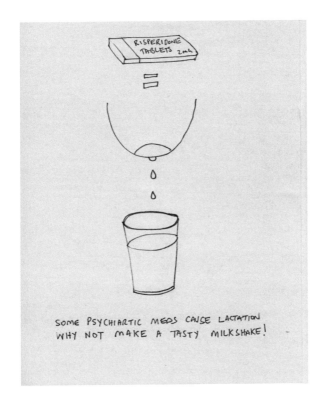

SOME PSYCHIARTIC MEDS CAUSE LACTATION
WHY NOT MAKE A TASTY MILKSHAKE!

WHY NOT ADD

STRAWBERRIES

1/4 tsp VANILLA

ICE CREAM

to the lactated milk

IF YOU CAN'T AFFORD A BLENDER DUE TO YOUR SANCTIONED BENEFITS, YOU CAN USE YOUR HAND TREMOR TO STIR. NO USE MOANING ABOUT SIDE EFFECTS, THERE ARE ALWAYS POSITIVES. TURN THAT FROWN UPSIDE DOWN! UNLESS MEDS HAVE GIVEN YOU HYPERSALIVATION (PLEASE SEE 'HYPERSALIVATION COCKTAILS' FOR EXCITING RECIPES)

VOILA! A DELICIOUS STRAWBERRY ICE CREAM DRINK TO GIVE TO YOUR CARE COORDINATOR OR BENEFIT ASSESSOR. DON'T FORGET TO TELL THEM WHICH TIT IT CAME FROM!

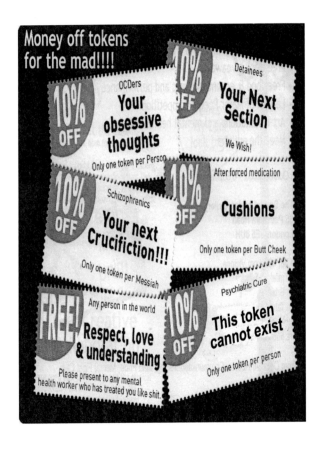

Go to Page 12 to find out A List of Ways to Guarantee Madness (or how psychiatry signposts)

YOU WILL SOON RETURN TO
YOUR NORMAL PROGRAMMING

DOLLY SEN - ARTIST STATEMENT

Prolific and versatile, my works spans words, visual and conceptual art, film, sound, performance, digital and mischief. I am interested in non-consensual reality, outsidership, empathy, authenticity and absurdity. I aim to disrupt systems that produce 'copy and paste' identities/thoughts/perceptions/life/death, not through Trojan horse viruses but with My Little Ponies on acid with a little sadness in their hearts.

Ultimately I think reality is a cheeky bastard, and I am putting him over my lap and slapping his naughty arse through my art, but I have hugs for everyone else.

dollysen.com

www.eleusinianpress.co.uk